Barns of America

Adult Coloring Book

By

Daniel J. Johnson

Dedicated to all who love the Barns of America

Copyright © 2018 All rights reserved. No part of this publication may be reproduced without the consent of the owner.

Daniel J. Johnson

ISBN: 9781790720453

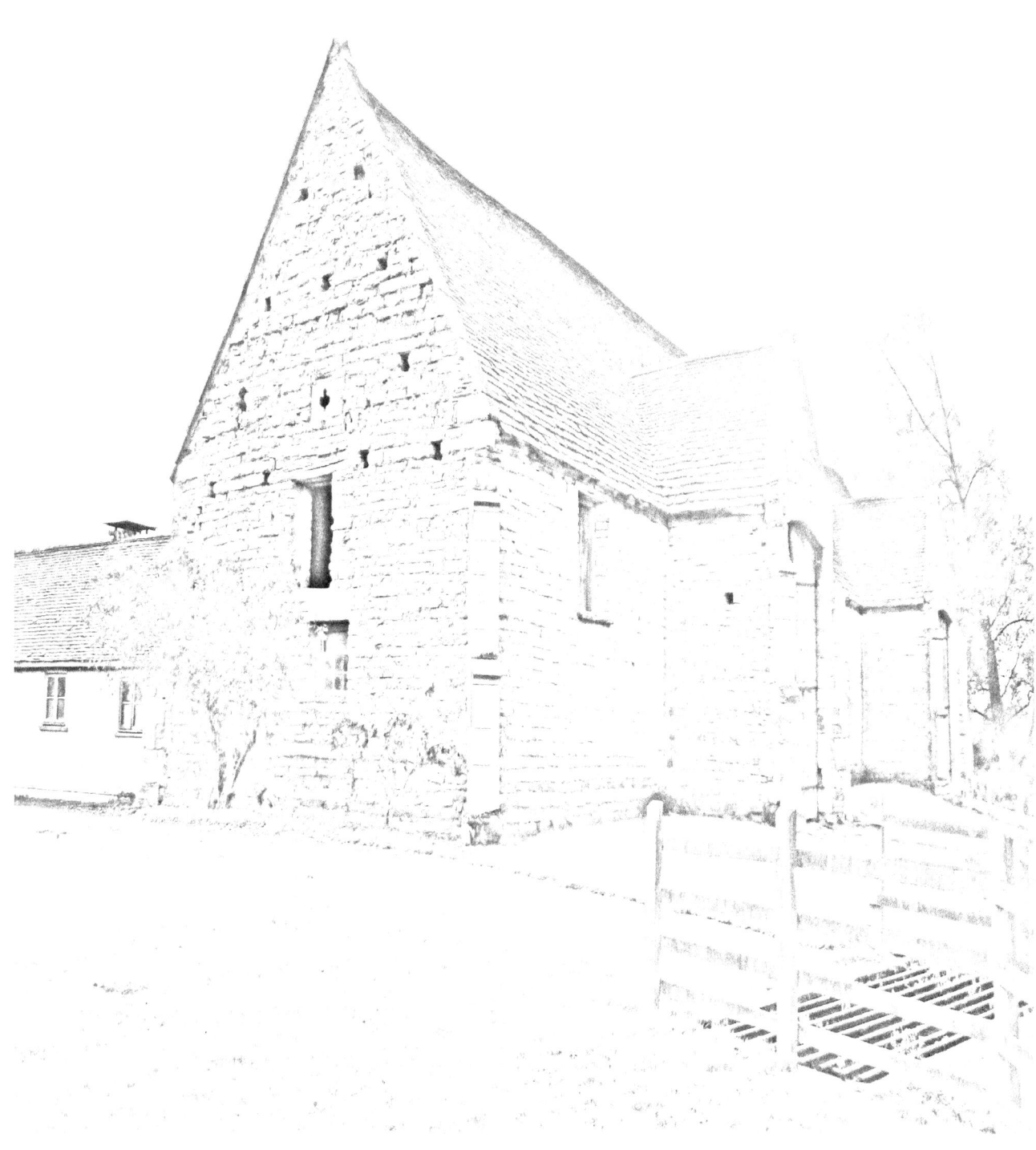

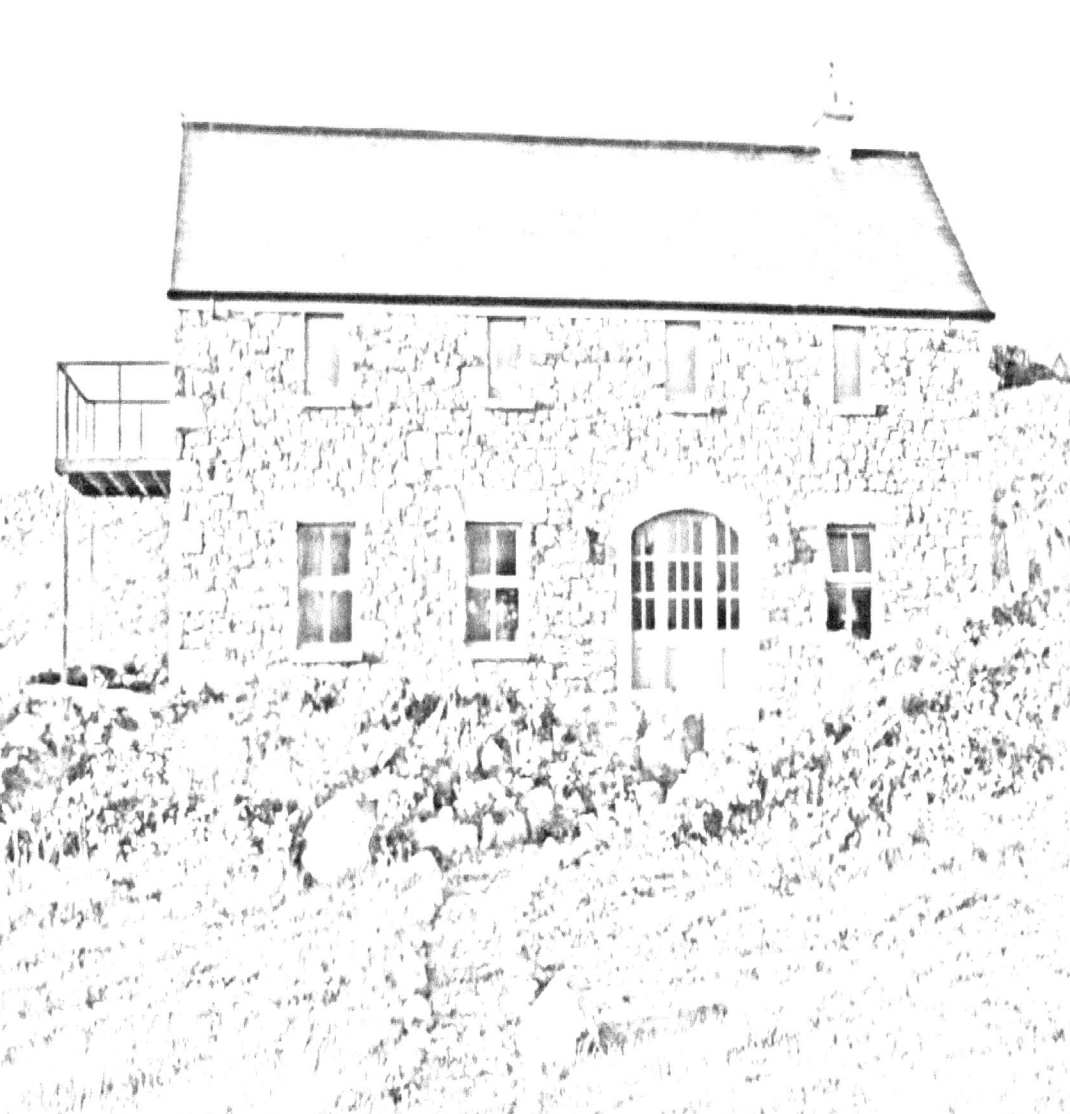

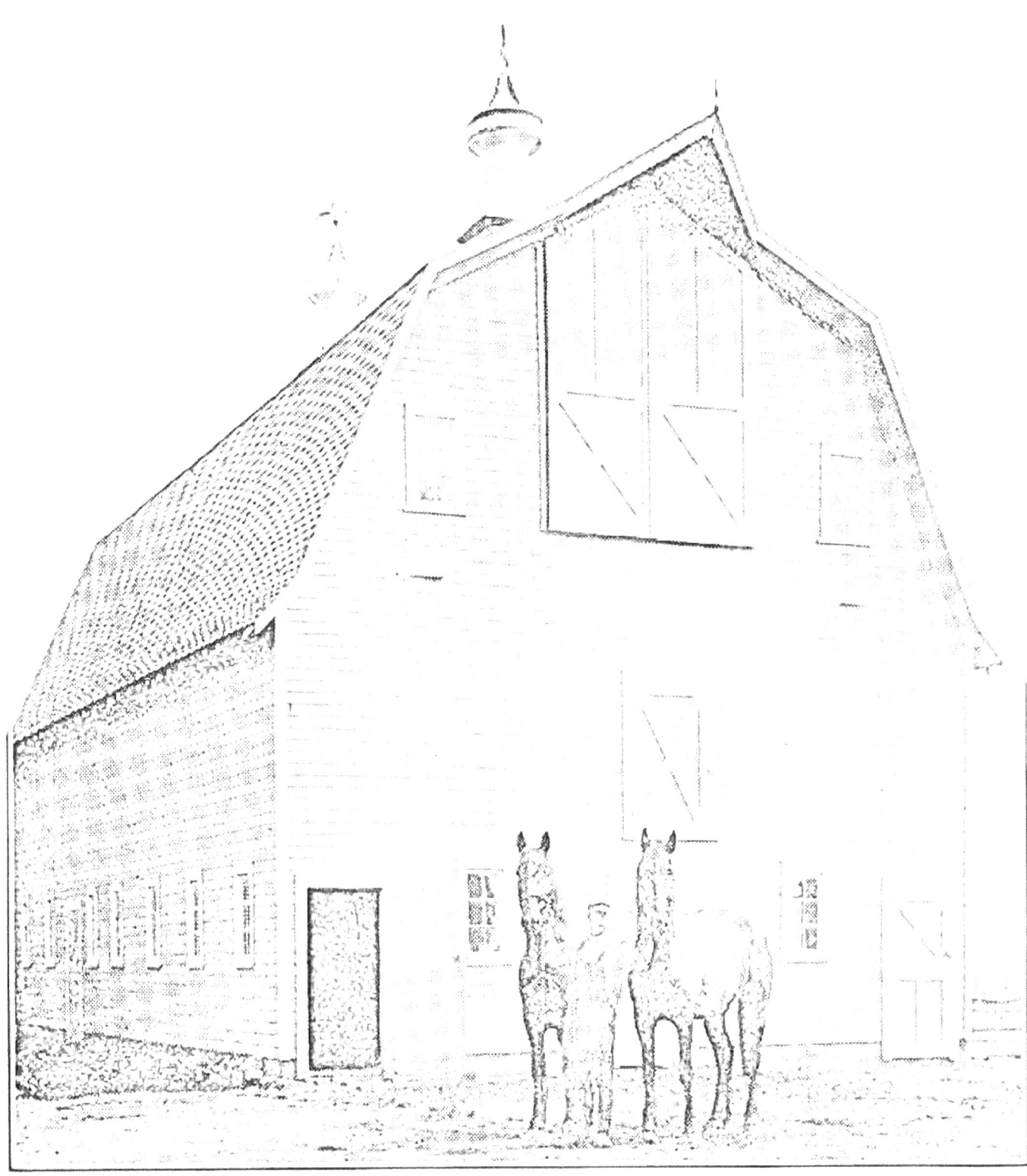

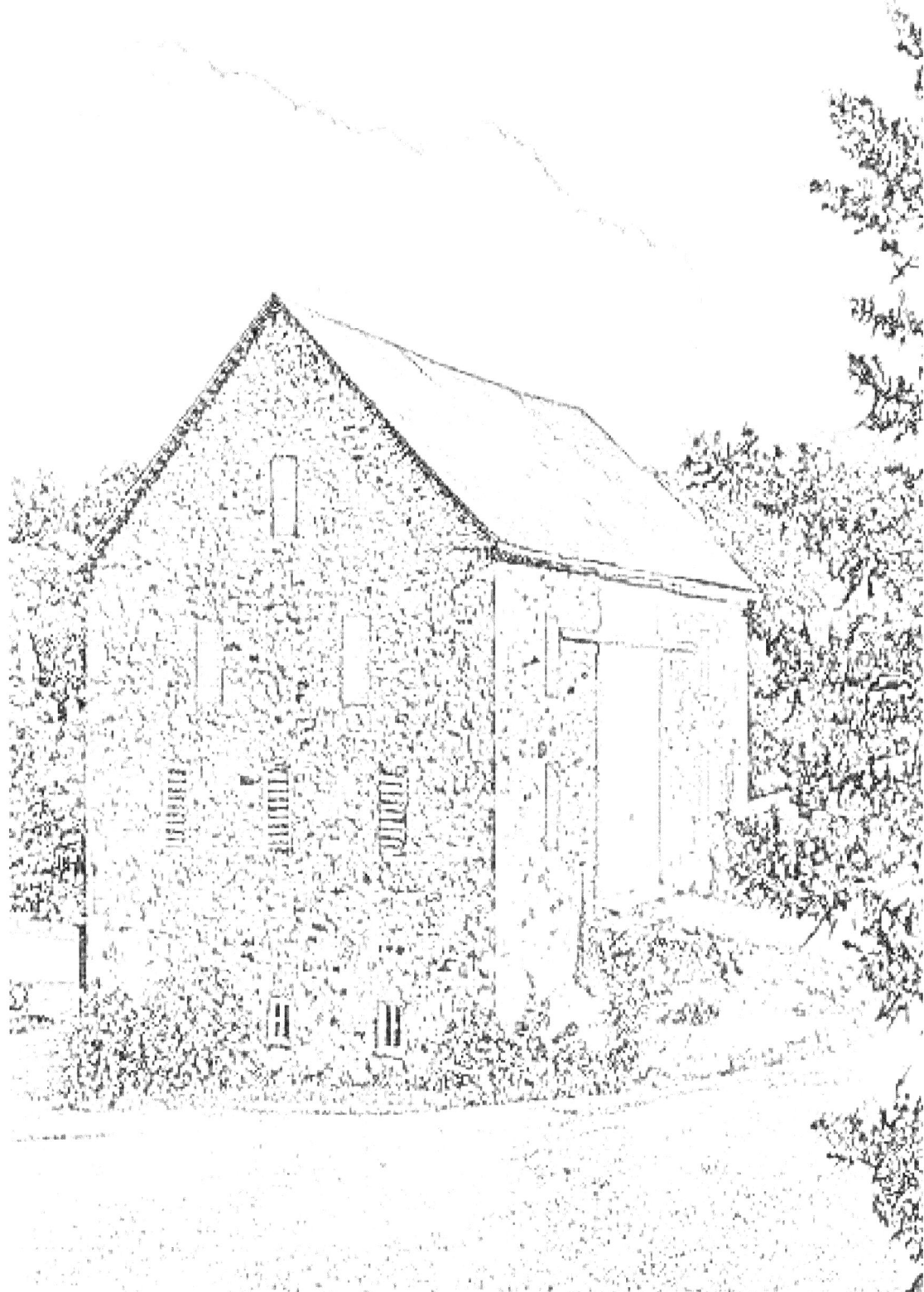

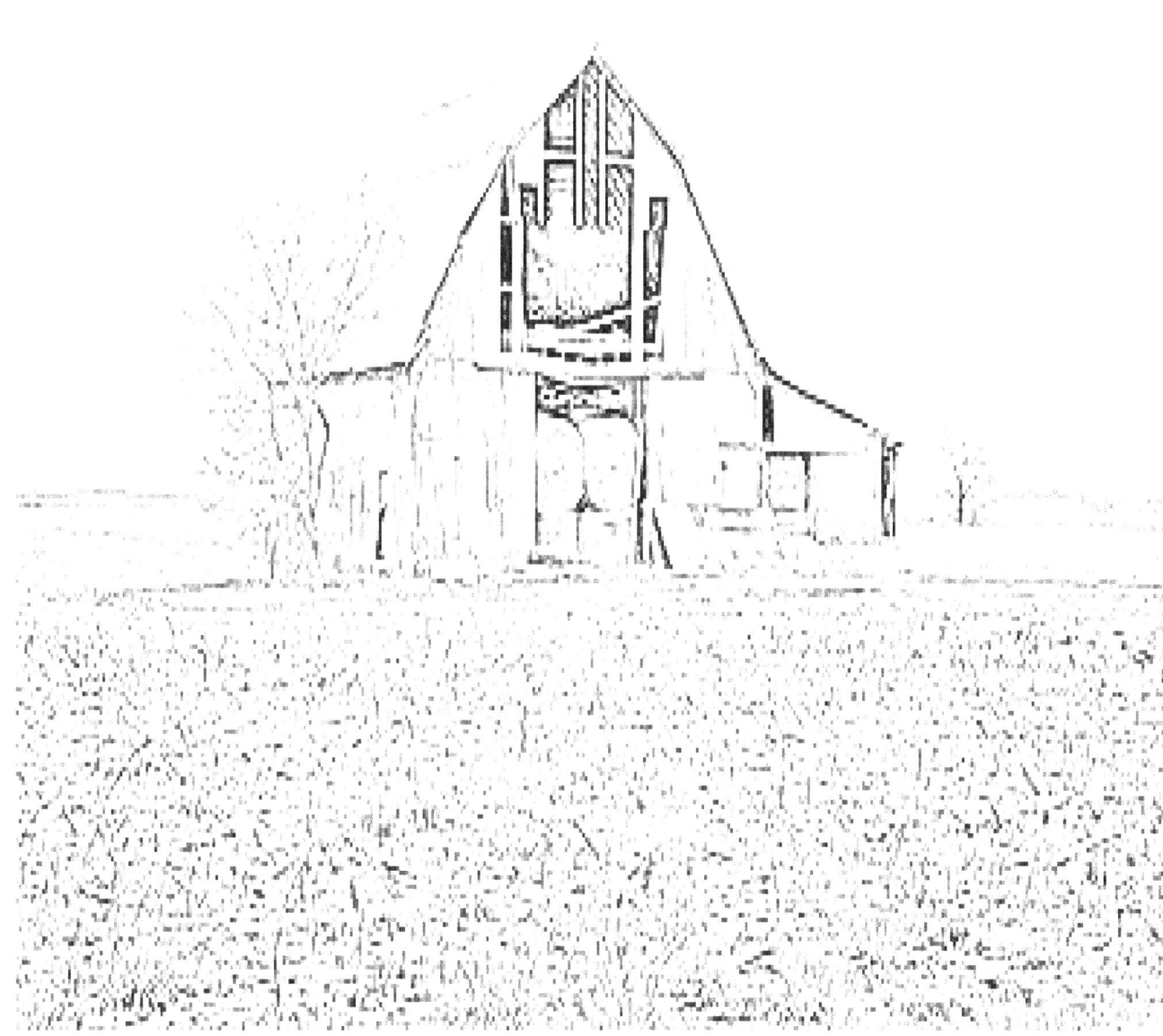

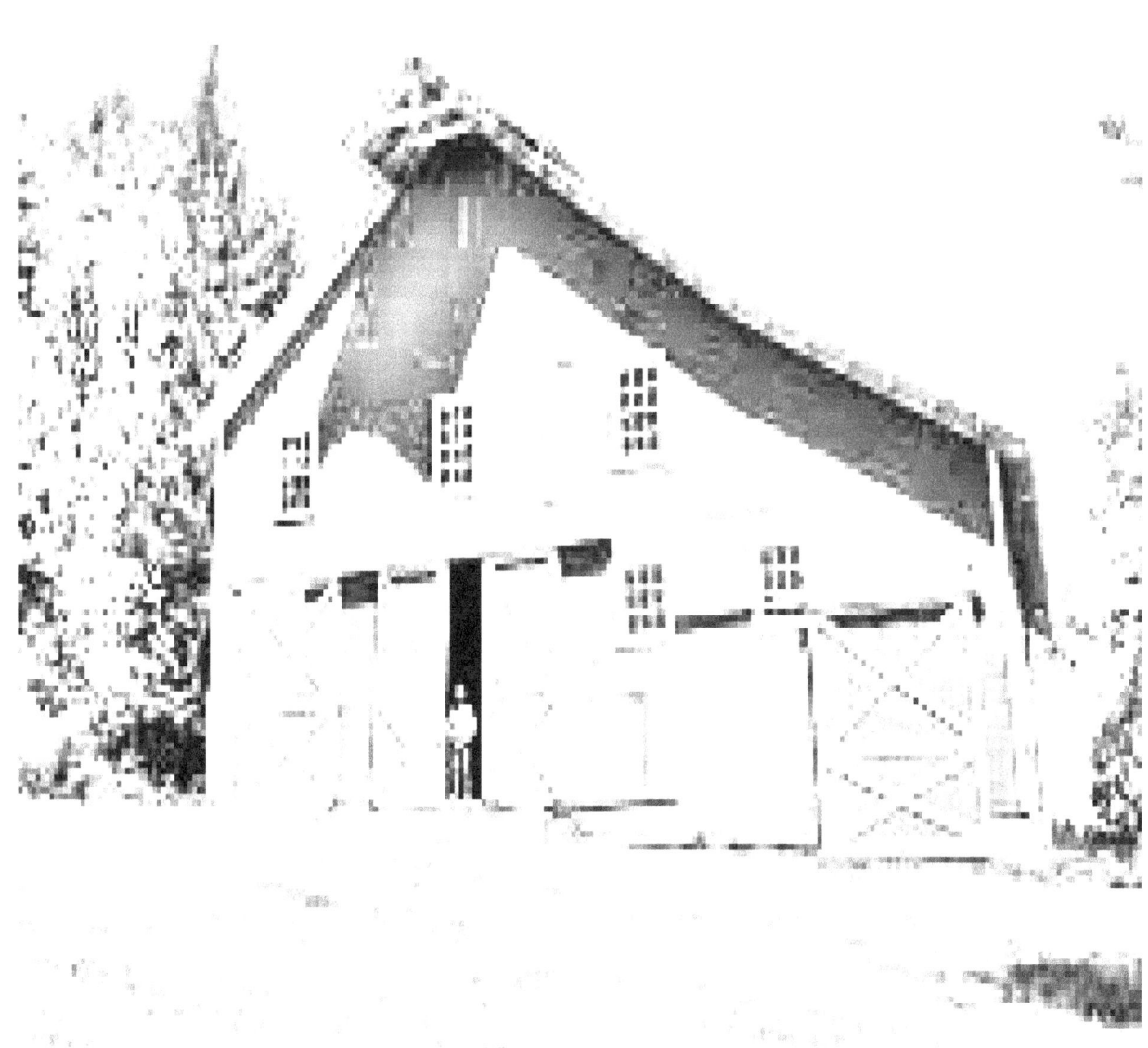

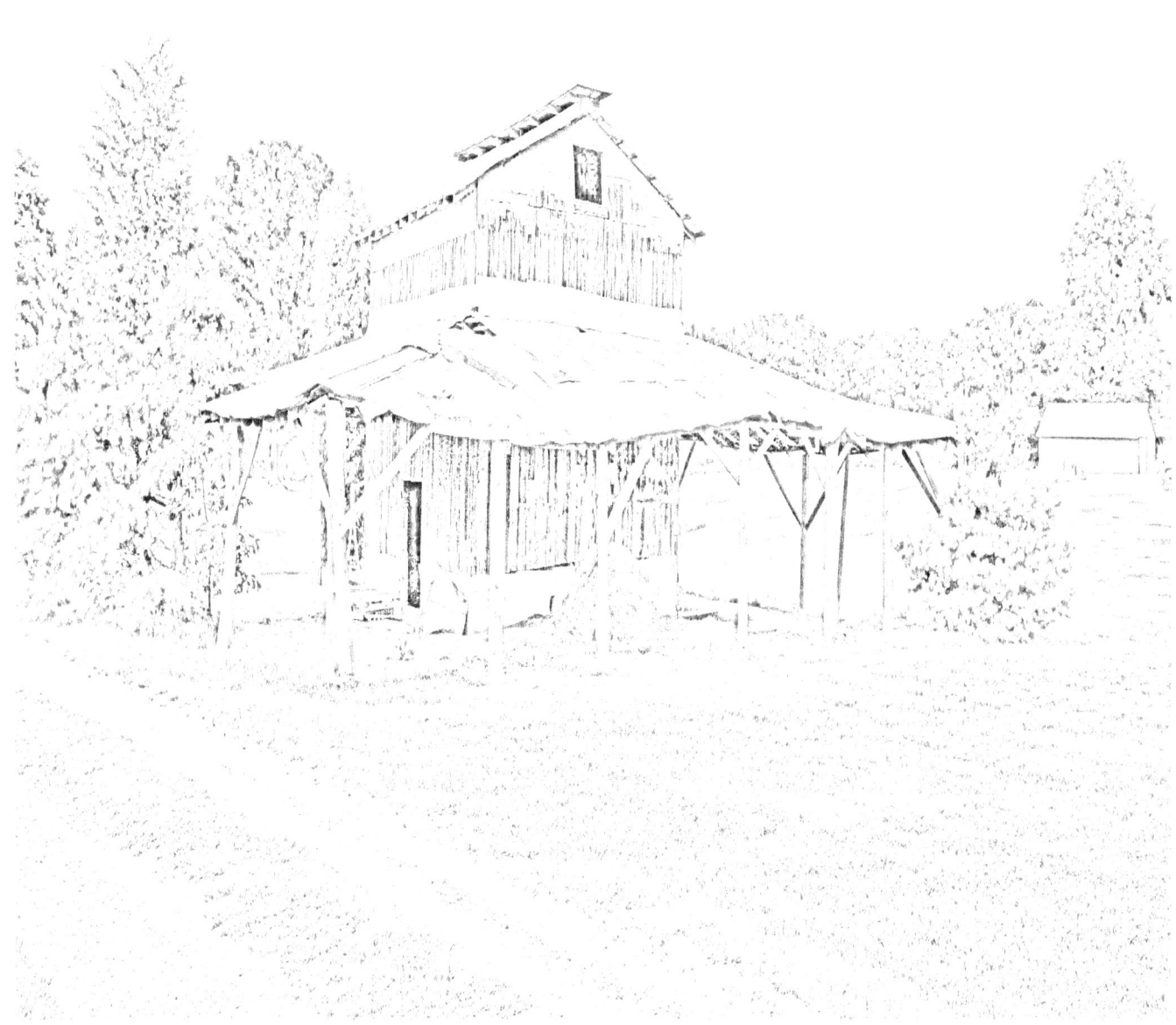

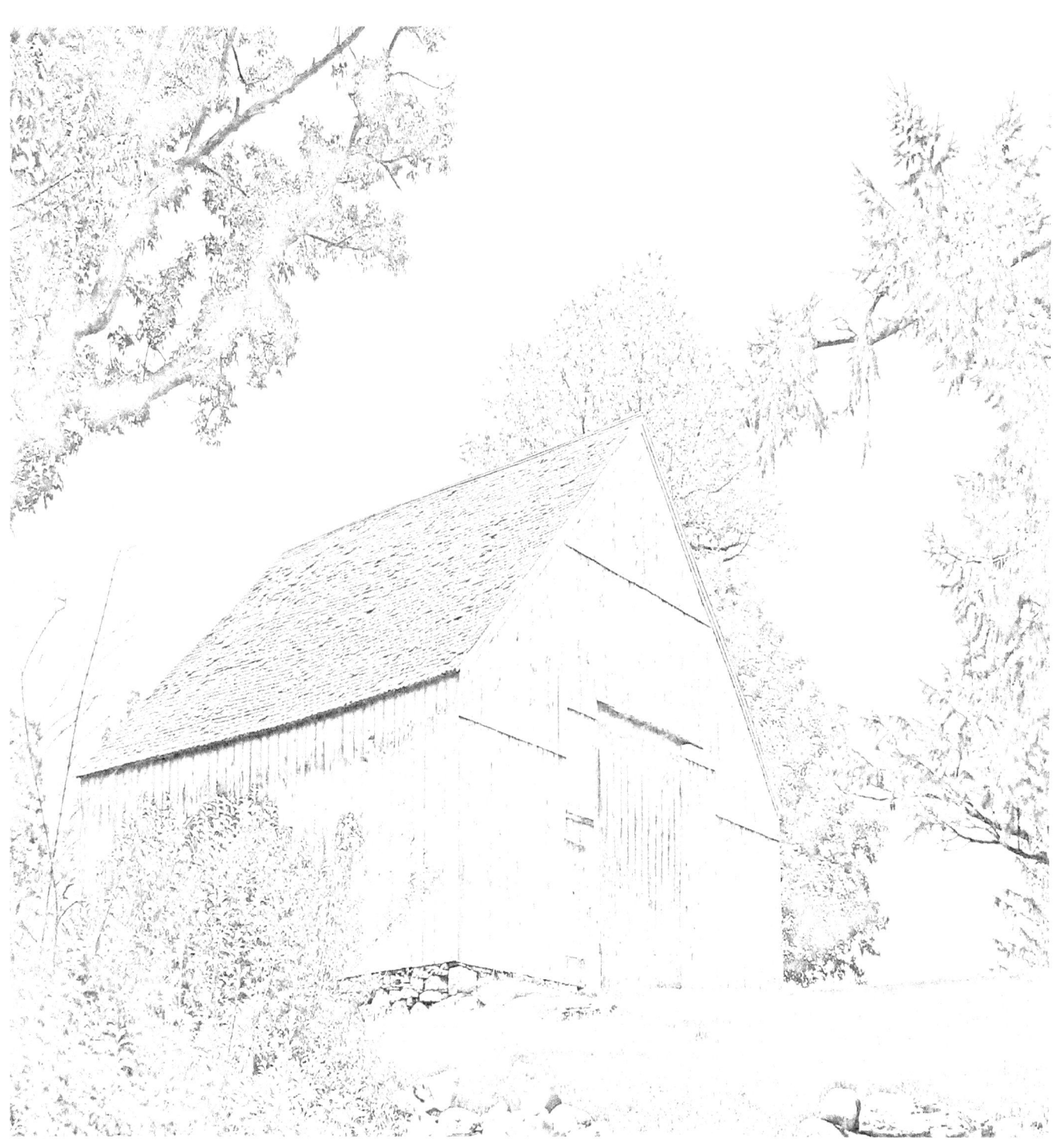

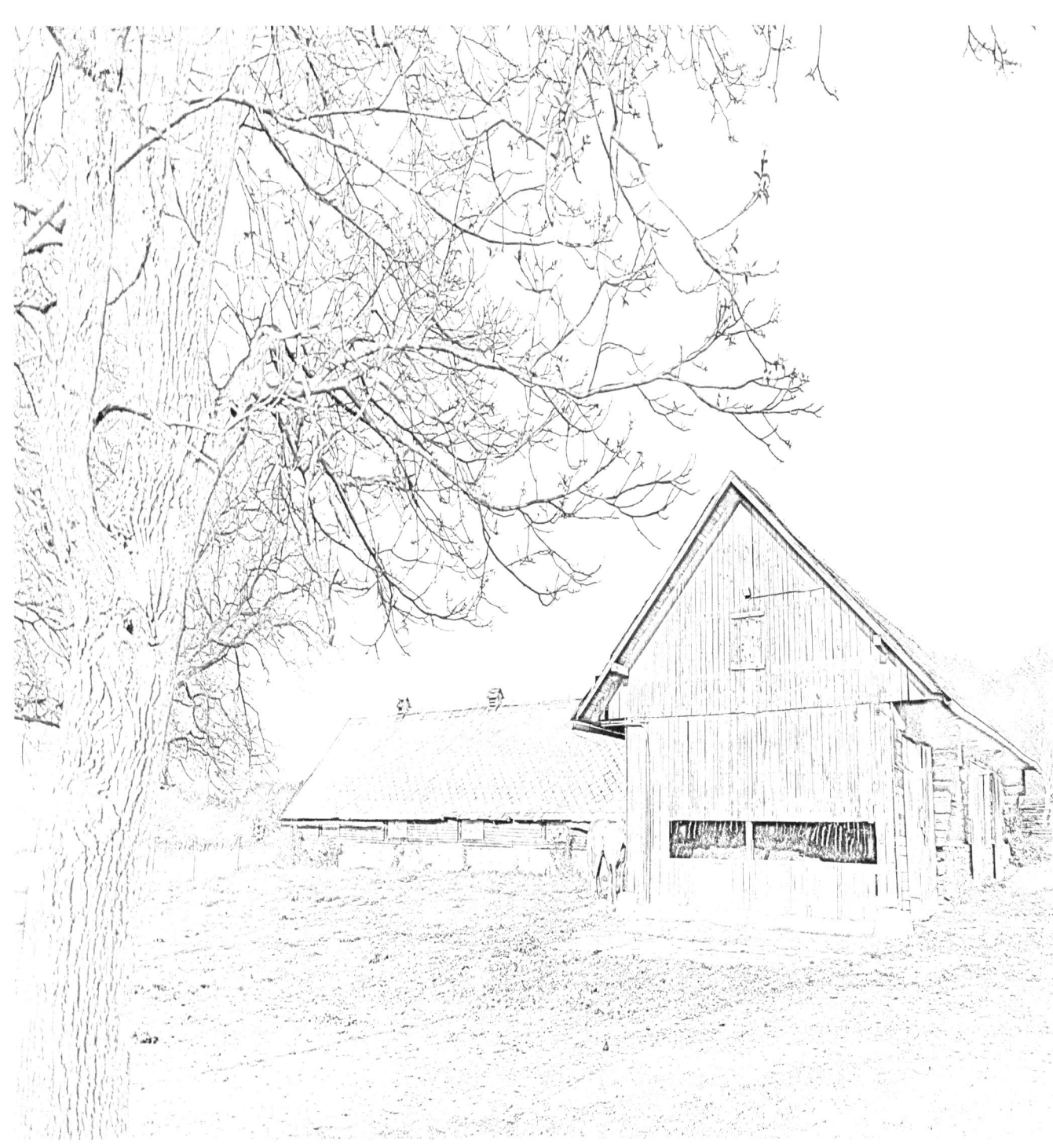

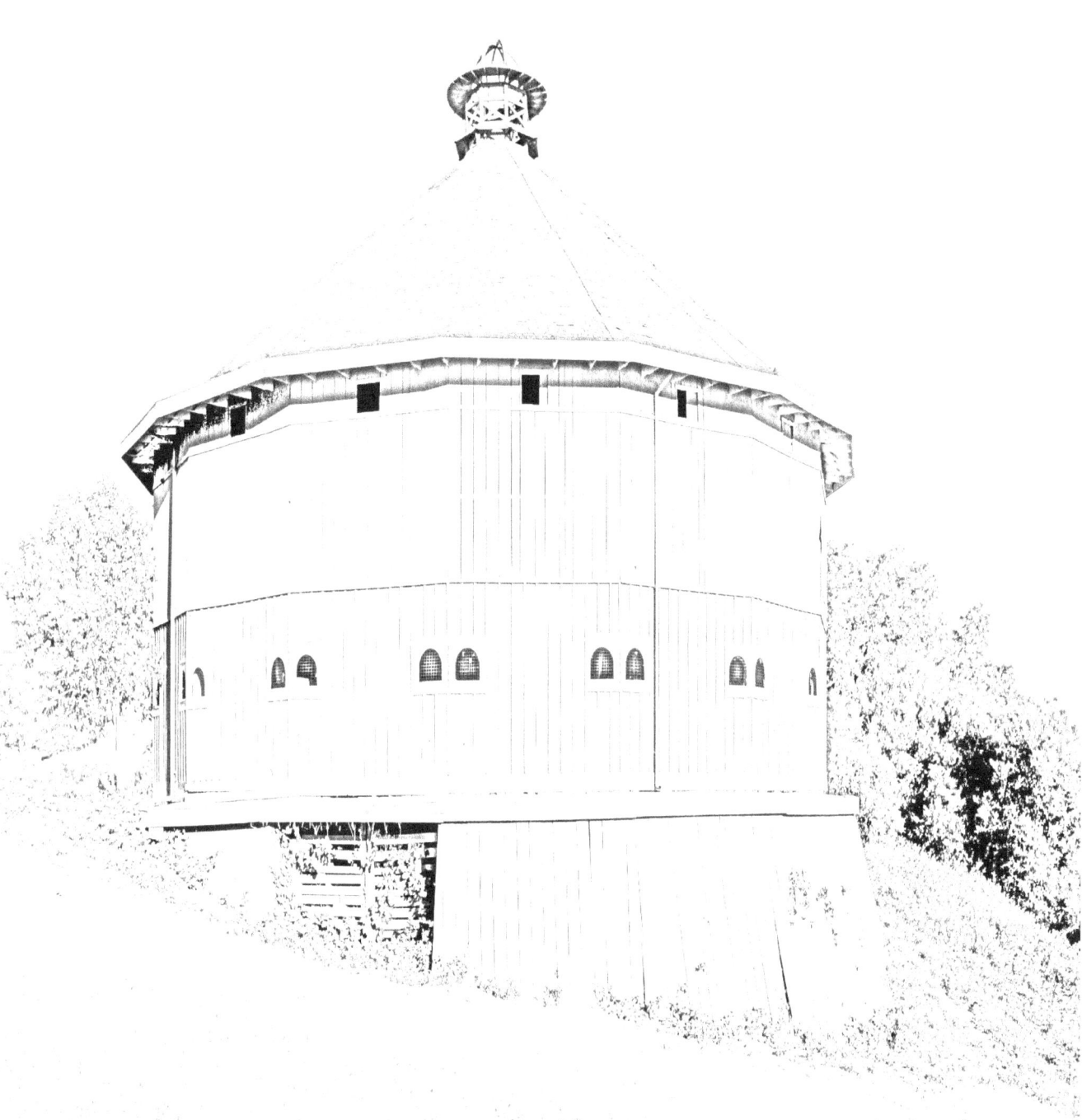

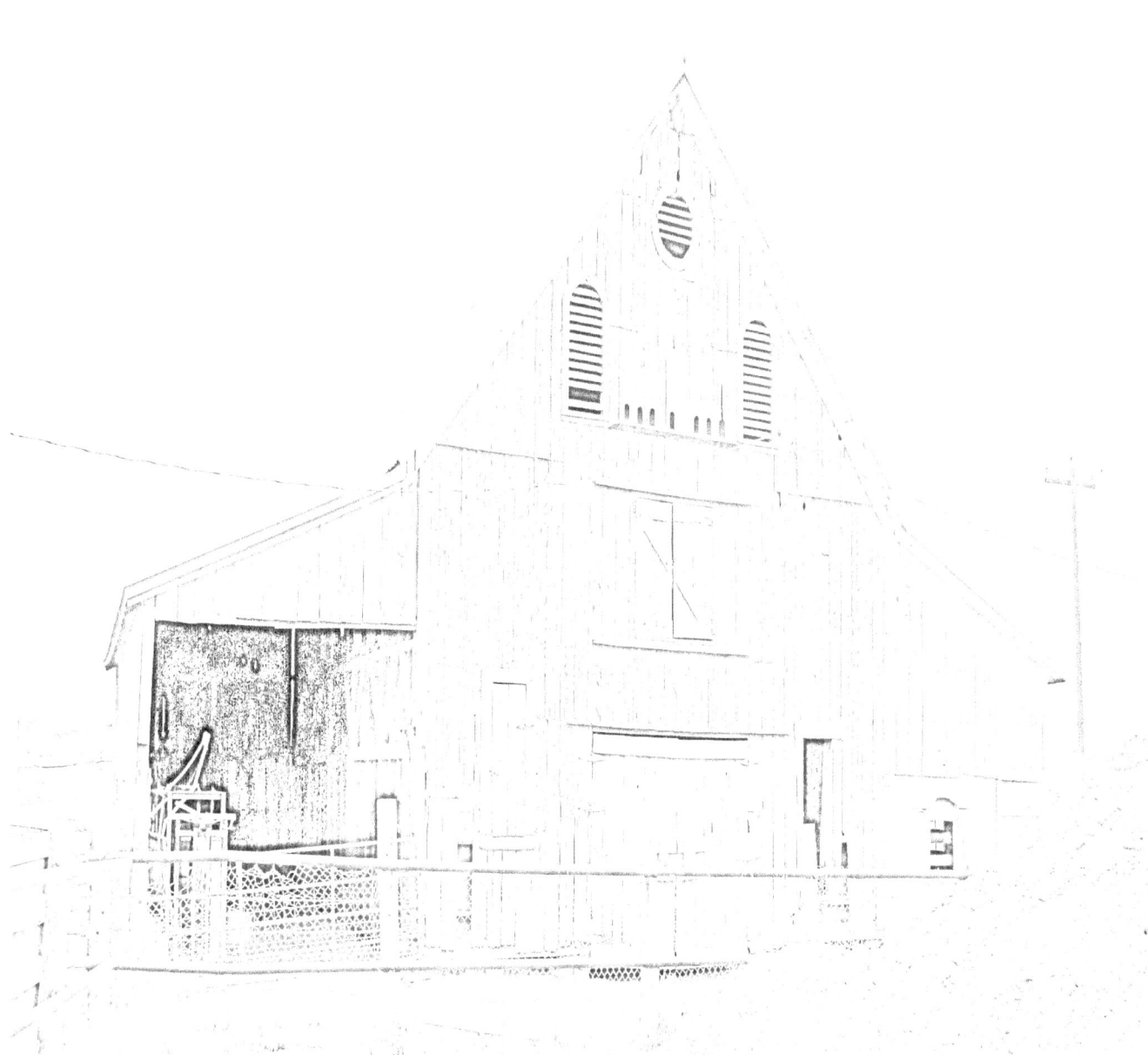

Lets Keep in touch! Visit our website at

https://itsfun2color.com

There you can find all the great Adult Coloring Books in the "Its Fun to Color" series

And always remember,
It's Fun to Color !!!

www.ingramcontent.com/pod-product-compliance
Lightning Source LLC
Chambersburg PA
CBHW081624220526
45468CB00010B/3011